MORPHO

anatomy for artists

Simplified

d

s

Michel ... ella

rockynook

Morpho: Simplified Forms: Anatomy for Artists
Michel Lauricella

Editor: Joan Dixon
Project manager: Lisa Brazieal
Marketing coordinator: Mercedes Murray
Graphic design and layout: monsieurgerard.com
Layout production: Hespenheide Design

ISBN: 978-1-68198-448-3
1st Edition (8th printing, November 2023)

Original French title: Morpho: Forms synthétiques
© 2017 Groupe Eyrolles, Paris, France
Translation Copyright © 2019 Rocky Nook, Inc.
All illustrations are by the author.

Rocky Nook, Inc.
1010 B Street, Suite 350
San Rafael, CA 94901
USA
www.rockynook.com

Distributed in the UK and Europe by Publishers Group UK
Distributed in the U.S. and all other territories by Publishers Group West

Library of Congress Control Number: 2018955182

Publisher's note: This book features an "exposed" binding style. This is intentional, as it is designed to help the book lay flat as you draw.

table of contents

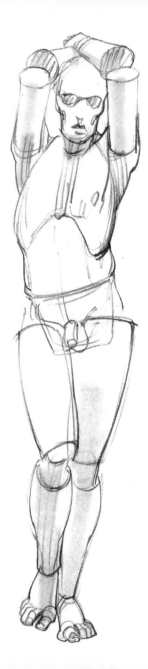

foreword

This book is about diagramming the human body with the goal of learning to draw from your own imagination. We begin with the complex form, which can be observed in living models, and then, by way of an anatomical analysis, we will deduce from that the simplest shapes that best approximate the human form, while still allowing for variations in posture.

The proportions used in this book are that of an adult, reduced to their most basic essence, with no distinction based on sex or age. The resulting figures are, of course, neutered and asexual, but the construction of complex shapes in space may justify this loss of information.

We will use simple orbs, boxes, and cylinders, which will, with their surfaces and shapes, represent the various segments of the human body. After completing a drawing of the basic form, the work of establishing specific details (the subtleties of contours and the personality of your model) will remain to

be done. We hope that by way of this shortcut—using the simplified form— you will learn to use this as a foundation for your work and will enrich your repertoire of poses.

While we believe that drawing from a live model is irreplaceable, the approach used in this book is to forego use of a model. If you strictly want to draw from live observation, the simplification proposed here runs the risk of weakening your drawing and *making it less sensitive.*

This book makes sense when you are drawing without a model. If you choose to redraw the drawings proposed here, by all means feel free to vary their poses and proportions. Ultimately, the goal is to learn to draw from your own imagination.

Finally, the rendering of the human body into simple shapes should facilitate your understanding of the folds of skin and clothing, which will often coincide with the ellipses that we will place at the level of the joints.

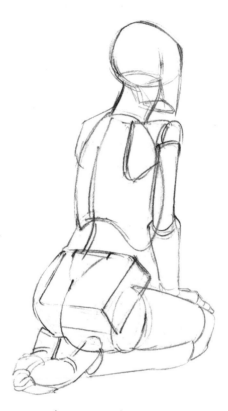

introduction

In order to avoid repeating a fixed repertoire of memorized poses, our goal is to learn to draw from our own imaginations in a way that relies on a limited set of geometric shapes that are easy to arrange according to our needs. Boxes, orbs, and cylinders will be the main shapes in our repertoire, but we will also rely on the skeleton as much as possible. Thus, the head will be entirely built around a simplified skull; the

rib cage will keep an ovoid shape; and the pelvis, reduced to a simple box, will protrude beneath the skin at its upper contour. The shapes of the elbow and knee joints can be traced back to the skeletal frame. The extremities (hands and feet) are mostly bony, and their diagramming also evokes the skeleton.

This book is divided into four main sections: head and neck, torso, upper limb, and lower limb.

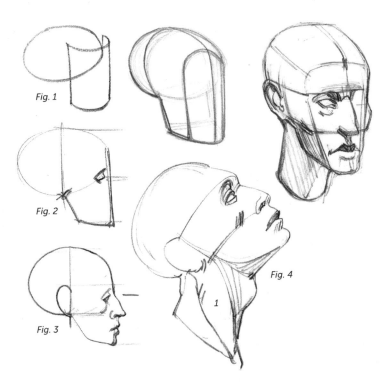

Fig. 1

Fig. 2

Fig. 3

Fig. 4

1

The Head

The skull can be reduced to two main shapes: the ovoid cranial box, and, in front of that, the curved, vertical surface of the face (Fig. 1). The lower jaw, the only mobile bone in the head, extends from the face downward. Its triangular base forms the chin and is attached to the skull at the halfway point of the skull's egg shape, in a profile view (Fig. 2). The ear is positioned just behind this connection point (Fig. 3). For the purposes of this book, we do not need to go into any further detail than that. We will rely on the classical proportional canon—used by da Vinci and

Dürer, among others—to estimate the placement of the eyes, the nose, the mouth, and the height of the ears. The eyes are at the halfway point, and the ears are at the height of the nose and are placed, as we have just seen, behind the jaw. Notice that this distance is often underestimated. The ears, which are positioned under two circular arcs set at the height of the nose, will allow us to convey the head's tilting motions. A simple cylinder will indicate the orientation of the neck, on which we will sometimes show the oblique volume of the sternocleidomastoid muscle (1, Fig. 4).

Fig. 1
Fig. 2
Fig. 3
Fig. 4
Fig. 5

The Torso

The rib cage can be reduced to an egg shape, which is sliced obliquely across the top to make it coincide with the ellipse at the base of the neck (Fig. 1). Its lower end is cut along the contours of the inverted V created by the ribs that are clearly visible on a live model.

For certain shortcuts, we will choose a simplification in the shape of a box; a radical reduction that offers us a better view of the depth. When the egg shape is foreshortened, it loses its characteristics and begins to look like a sphere (Figs. 2 to 4).

The pelvis is drawn like a large matchbox, laid on one of its long sides. In the middle of its front side we find the pubis (Fig. 5), a bone reference point, placed just above the sexual organs, which serves as a marker of the halfway point of a standing body in many proportional canons (da Vinci, Dürer).

In certain cases we will choose a different shape, closer to its exterior shape, following the oblique path of the flexural folds (Fig. 6).

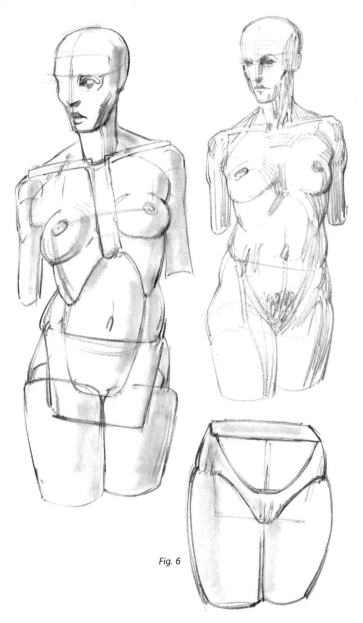

Fig. 6

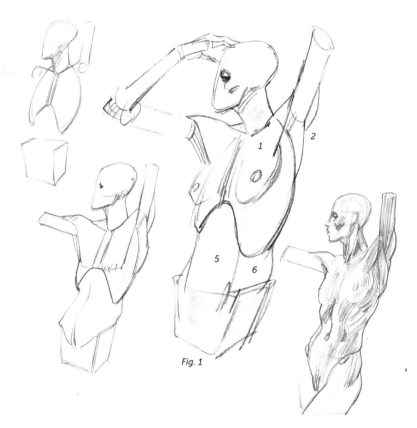

Fig. 1

Starting from the torso, we find the arm muscles that are responsible for lowering the pectoral muscles (1), and the united teres major and latissimus dorsi muscles (2), which delineate the walls and define the hollow of the armpit (Fig. 1). Associated with these muscles are the scapular belt, which is made up of the shoulder blades and the clavicles. Our simplification must include the drawing of these bones because they follow all the movements of the arm and create major changes in shape. The shoulder blades are essential to the drawing of this area. They are two triangular plates that function as relay platforms for the muscles of the upper limb. These plates slide and pivot on the rib cage and follow all the movements of the arm. Thus, they tilt to point upward when the arm is raised. We will concentrate here on the bracket created by the shoulder blades, rather than detailing the muscles that cover

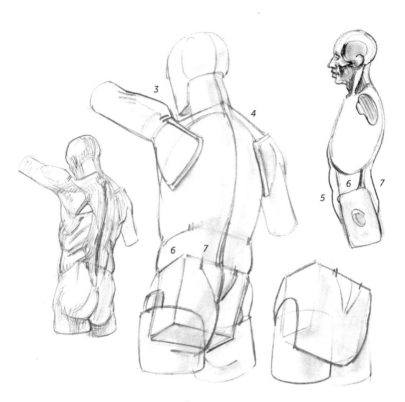

them. For those muscles, we will simply use their outline, which connects the rib cage to the arm.

These muscles form the rear wall of the armpit and can be seen more clearly when the arm is raised.

The deltoids (3) and trapezius muscle (4) will be indicated by their outlines. At the shoulder, the trapezius is connected to the neck and the deltoid to the arm. We find that the clavicle is most interesting in views from above because it emphasizes the rounded-

ness of the rib cage. In those cases, we will draw it, but most often, it will disappear within the more important shape of the pectoral, which takes up the front wall of the armpit.

The muscles that connect the rib cage to the pelvis create a uniform whole, connected by the fat that is often thicker in front and on the sides. These are the abdominals, rectus abdominis (5) and obliques (6), to which one can add the spinal muscles that run along the spinal column.

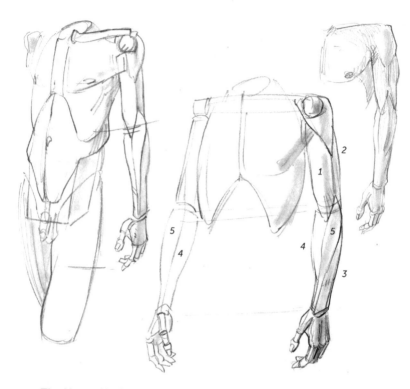

The Upper Limb

Left to hang down along the body, the hand comes to mid-thigh. The elbow joint is halfway between the top of the shoulder and the end of the back of the hand (when it is made into a fist). The shoulder joint can be drawn as a sphere that is visible in front, corresponding to the head of the humerus. The arm itself becomes a simple cylinder. We can give it a slightly oval cut in the front-to-back direction, given that the muscles are basically distributed with the biceps (1) in front or the humerus and the triceps (2) in back.

We find a bone reference point at the elbow: The tip of the ulna forms an angle that can be exaggerated in order to reinforce the presence of the bone.

The forearm creates a conical shape. Its fleshy muscular masses (the extensors, 3, and the flexors, 4) mostly come back together close to the elbow, whereas the tendons complete the shape near the wrist. Because the tendons are not very thick, we reinforce the bony presence at this level by flattening the lower part of this segment.

At the connection between the upper arm and the forearm, we have of-

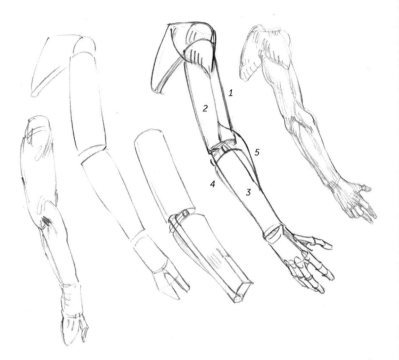

ten found it necessary to add a muscular element: the brachioradialis or long supinator (5), which follows the twists made possible by the way the joints are in this area, and expresses them on the surface. The radius and ulna cross (in pronation) and uncross (in supination), allowing the rotational movements of the hand.

The brachioradialis is inserted on the lower third of the arm and follows the thumb side of the forearm. Thus, when the thumb is brought back to the interior (pronation, the act of grasping), the muscle crosses the forearm diagonally. Conversely, it remains on the outside of the contour when the thumb is turned outward (supination, the act of supporting).

On the other side, the ulna (the elbow bone) can be drawn along the length of the forearm, as far as the wrist (on the side of the little finger).

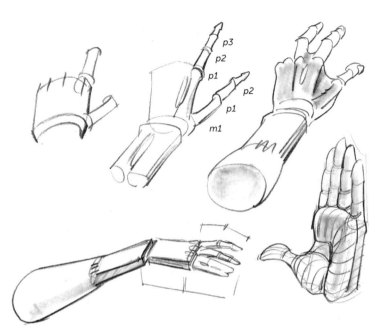

The hand (as with the foot) requires more focused attention.

The most useful proportions for the hand are easy to remember: The back of the hand, measured from the end of the ulna (the small bony ball on your wrist on the side of the little finger), is as long as the longest finger. The first phalange of each finger (except for the thumb) is equal to the length of the other two phalanges put together. The wrist is followed by the bones of the hand, each ending in a curved or arced shape. It is not important to distinguish the individual bones here. At the end of these arcs (at the end of a fist) four fingers begin. Each finger is made up

of three phalanges, drawn as simplified small cylinders.

The last item is the thumb. This opposable digit does not align along the same plane as the fingers. It starts from the wrist on the inside of the hand. The thumb, too, is drawn using three cylinders, even though it only has two phalanges (p1 and p2). This is because the thumb's metacarpal (m1) is distinct and is much more mobile than those of the fingers, which are all connected together on the same plane along the back of the hand.

Finally, we add a few fleshy volumes, both muscular and fatty, on the palm of the hand.

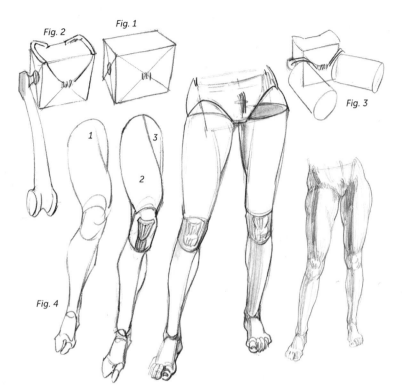

Fig. 2

Fig. 1

Fig. 3

Fig. 4

The Lower Limb

Measured from the hip joint to the ground, the leg can be divided at the knee joint into two equal parts. At the center of the small sides of the box representing the pelvis, we place the hip joints (Fig. 1), with the femurs being subcutaneous here (shaded area, Fig. 2). However, on many models, the fat in that area obscures the femurs' presence. Regardless, the flexural fold always indicates their positions (Fig. 3).

The cylinder of the thigh can take a conical form, narrowing above the knee. We will most often draw a diagonal line across this segment, corresponding to the passage of the sartorius muscle (1), which descends from the upper angle of the pelvis to connect with the inside of the knee (Fig. 4). This line makes it possible to separate the two principal masses of a thigh as seen from the front: the quadriceps (2) and the adductors (3).

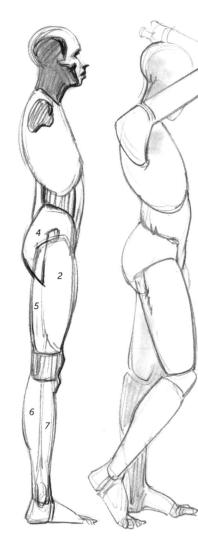

The buttocks (made up of fat) can be confused with the gluteal muscles (4). The buttocks are drawn as a contour that covers the hip joint on the side and at the back. The gluteus slides inbetween the quadriceps and the hamstrings (5).

The knee requires its own shape, as it is a joint area where the bones are dominant. We will most often represent the knee as a simple cubical form in order to reinforce (as with the elbow) the hard, angular presence of the skeleton. Then we will sometimes refine its shape by positioning the patella.

From the knee to the ankle, the leg is drawn as an elongated cone. Here, we again find characteristics similar to the forearm: fleshy and muscular forms above with more tendinous and bony forms close to the ankle. We are not always able to resist curving the shape of the leg somewhat in order to make it more attractive. In a profile view of a

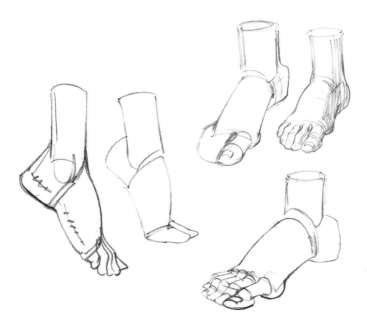

person in a standing position, the thigh and lower leg segments are not perfectly aligned one atop the other. The thigh is slightly prominent and pushes the knee to align with the midfoot in front of the ankle joint. This is due to the unequal distribution of the muscular masses on the thigh and on the lower leg. The femur is, in fact, entirely covered by the musculature of the thigh—particularly the powerful quadriceps in front—whereas the gastrocnemius muscle of the calf (6) is further back, and the anterior tibialis muscles

(extensors, 7) push the tibia to brush just under the skin in the front.

The foot is made up of three principal parts: the heel, the midfoot (domed on top and arched on the bottom), and the toes. As with the thumb, the big toe has only two phalanges, unlike the other toes that each have three (though the two last phalanges of the little toe are so small they seem to form just one).

Like the hand, the bones of the foot dominate the shapes on the top while a layer of fat cushions the sole.

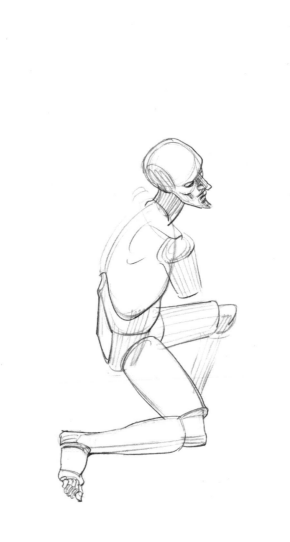

drawings

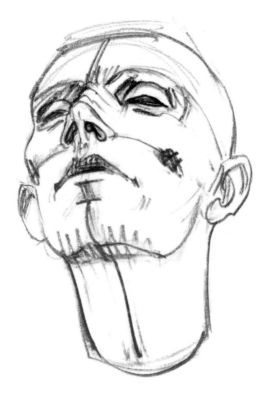

head and neck

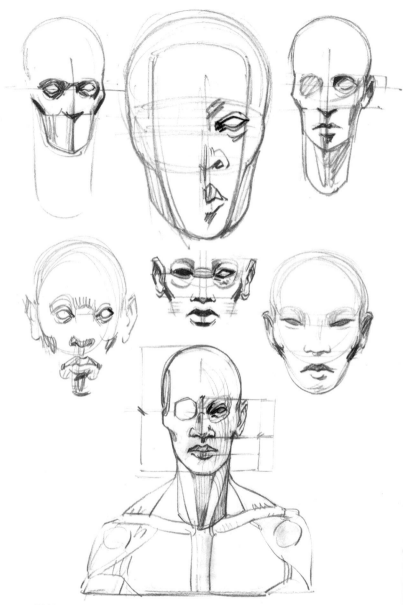

The eyes can be drawn halfway up the head.

The space between the eyes is about the same as the width of an eye.

The ears are at the same level as the nose.

The base of the nose coincides with the depressions underneath the cheekbones.

The height of the nose can be equal to the measurement from the bottom of the nose to the chin.

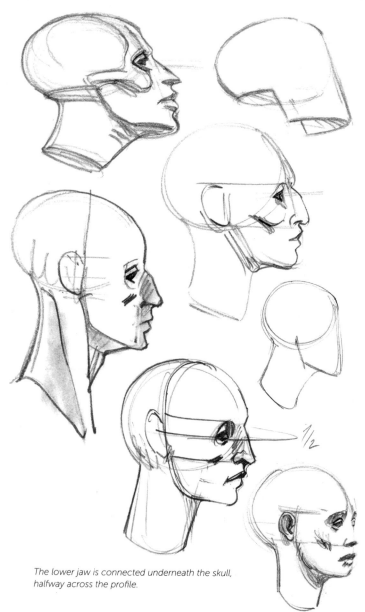

*The lower jaw is connected underneath the skull,
halfway across the profile.*

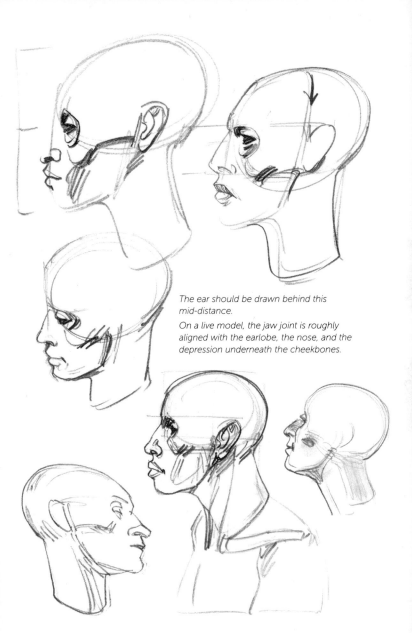

The ear should be drawn behind this mid-distance.

On a live model, the jaw joint is roughly aligned with the earlobe, the nose, and the depression underneath the cheekbones.

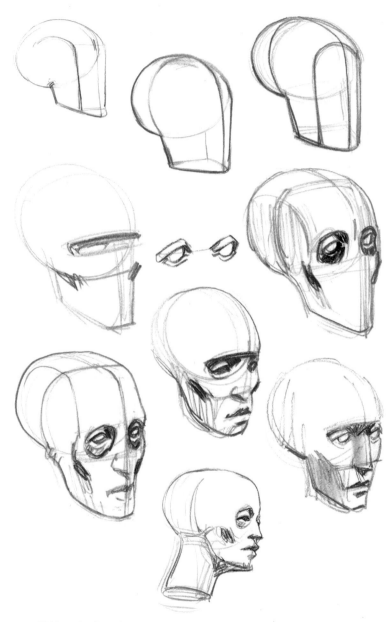

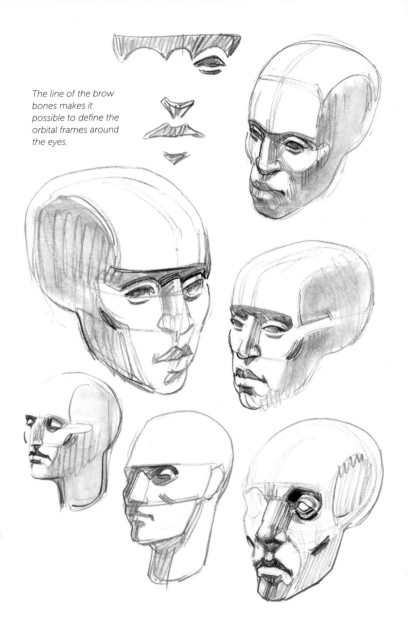

The line of the brow bones makes it possible to define the orbital frames around the eyes.

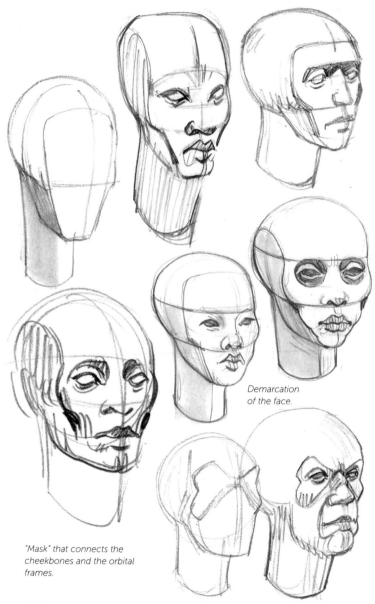

Demarcation of the face.

"Mask" that connects the cheekbones and the orbital frames.

The two sternocleidomastoid muscles that rotate and tilt the head (1) start at the skull under the ear, and connect to the sternum at the axis of the rib cage.

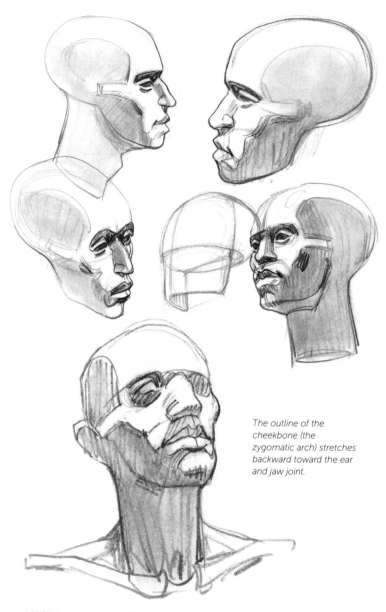

The outline of the cheekbone (the zygomatic arch) stretches backward toward the ear and jaw joint.

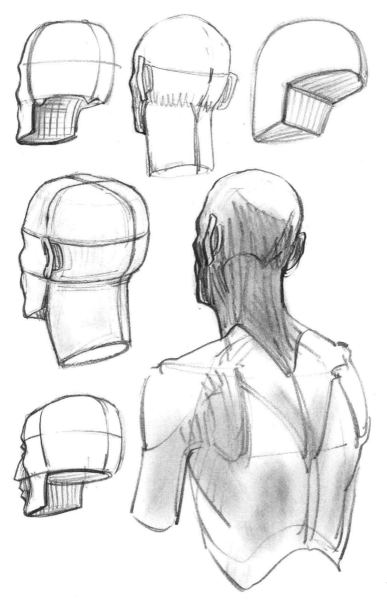

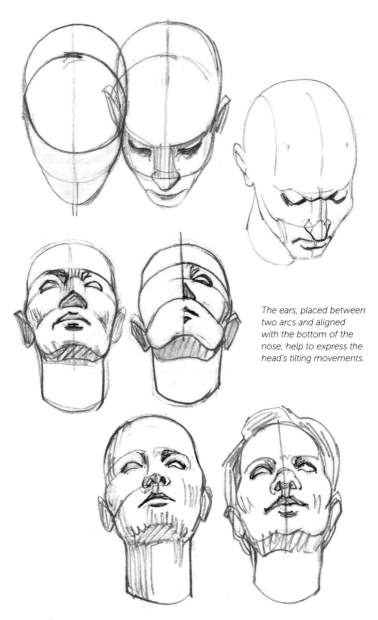

The ears, placed between two arcs and aligned with the bottom of the nose, help to express the head's tilting movements.

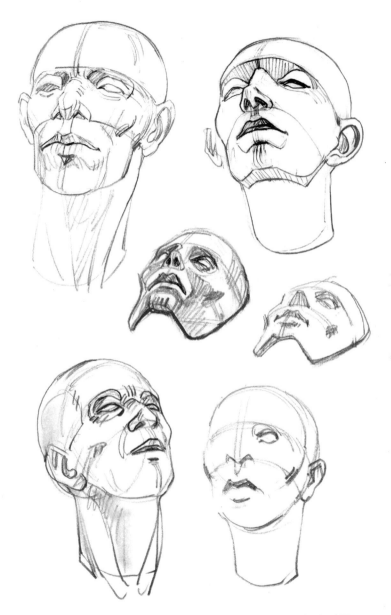

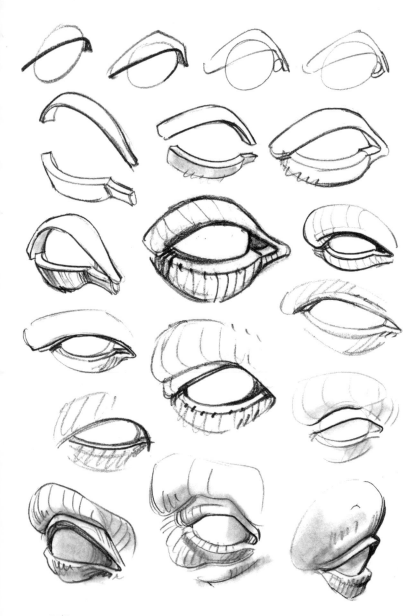

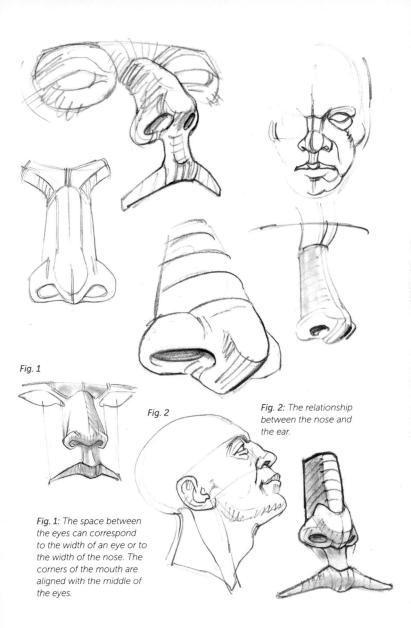

Fig. 1

Fig. 2

Fig. 2: The relationship between the nose and the ear.

Fig. 1: The space between the eyes can correspond to the width of an eye or to the width of the nose. The corners of the mouth are aligned with the middle of the eyes.

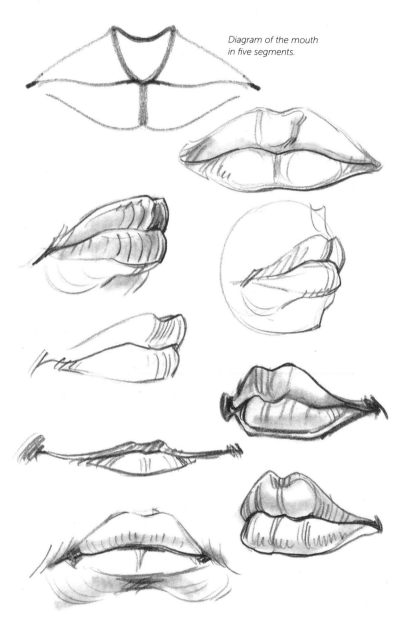

Diagram of the mouth in five segments.

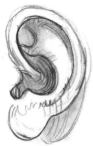
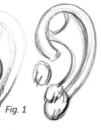
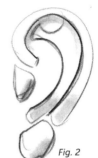

Fig. 1

Fig. 2

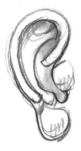
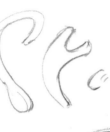

Fig. 3

Fig 1: The earlobe and the ear's cartilage form three round contiguous shapes.

Fig 2: Nnemonic device (following artist Normand Lemay):

$? + y =$

Fig. 3: Rear views. The circumference of the ear is twisted into an elongated "S" shape along the cartilaginous wall.

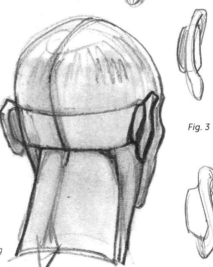

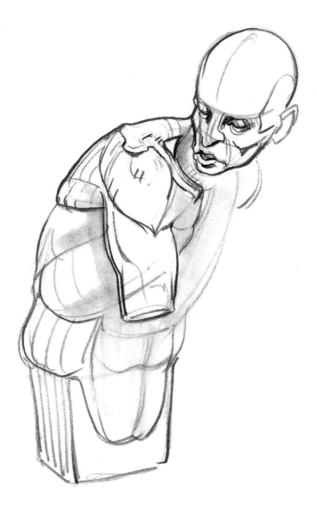

torso

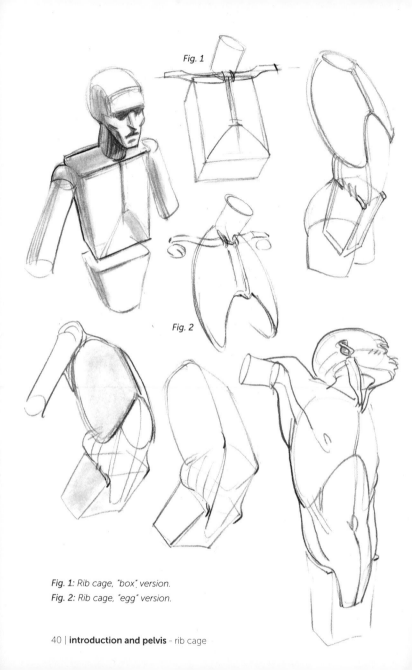

Fig. 1: Rib cage, "box" version.
Fig. 2: Rib cage, "egg" version.

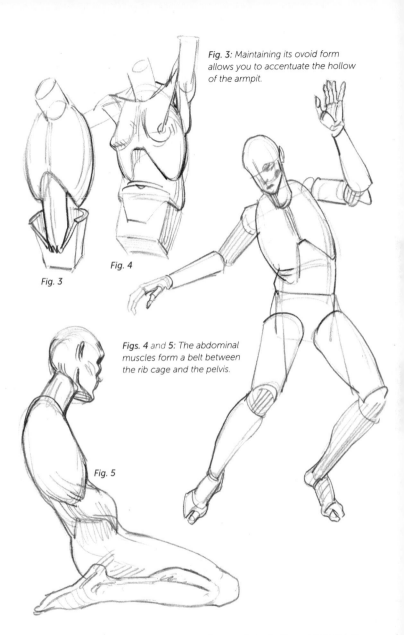

Fig. 3: Maintaining its ovoid form allows you to accentuate the hollow of the armpit.

Fig. 4

Fig. 3

Figs. 4 and 5: The abdominal muscles form a belt between the rib cage and the pelvis.

Fig. 5

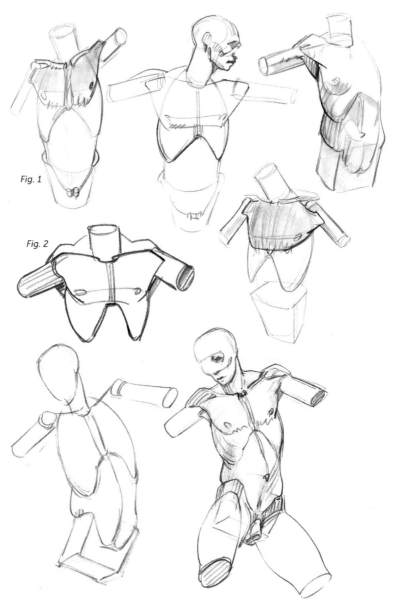

Fig. 1

Fig. 2

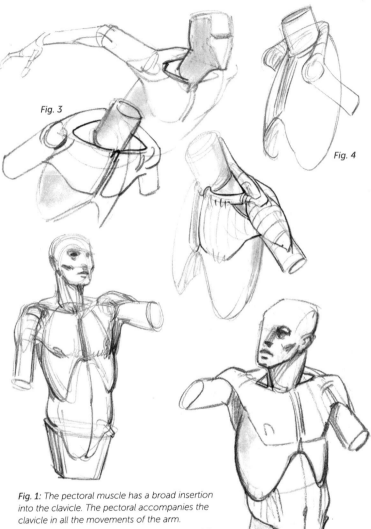

Fig. 3

Fig. 4

Fig. 1: The pectoral muscle has a broad insertion into the clavicle. The pectoral accompanies the clavicle in all the movements of the arm.

Fig. 2: Simplified version, with the clavicle and the pectoral muscle fused onto one plane.

Figs. 3 and 4: The trapezius muscle envelops the neck and then joins the shoulders in the front.

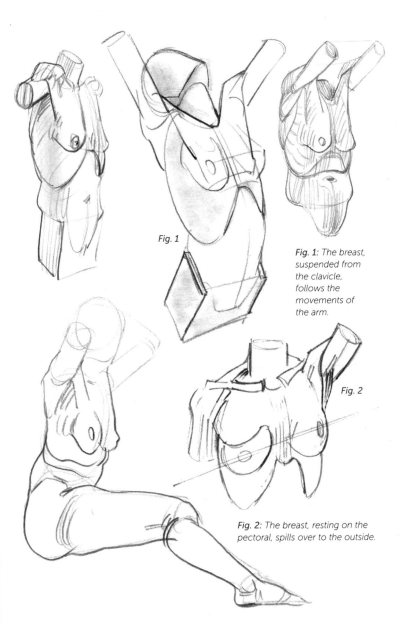

Fig. 1

Fig. 1: The breast, suspended from the clavicle, follows the movements of the arm.

Fig. 2

Fig. 2: The breast, resting on the pectoral, spills over to the outside.

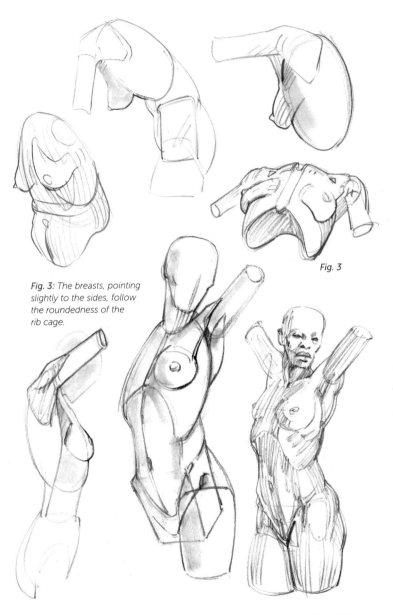

Fig. 3: The breasts, pointing slightly to the sides, follow the roundedness of the rib cage.

Fig. 3

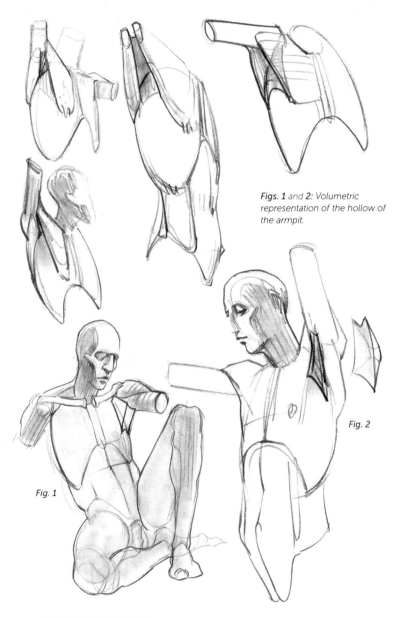

Figs. 1 and 2: Volumetric representation of the hollow of the armpit.

Fig. 1

Fig. 2

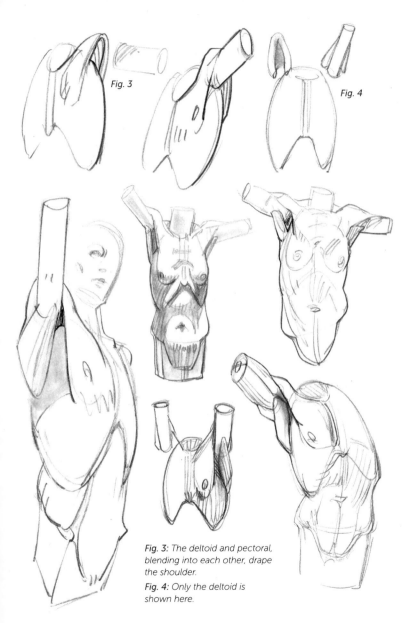

Fig. 3: The deltoid and pectoral, blending into each other, drape the shoulder.

Fig. 4: Only the deltoid is shown here.

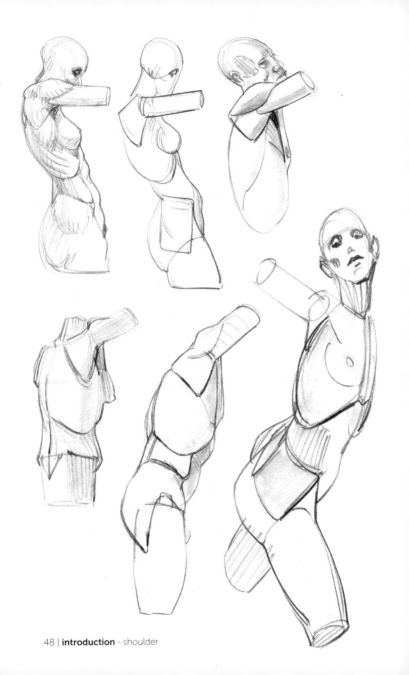

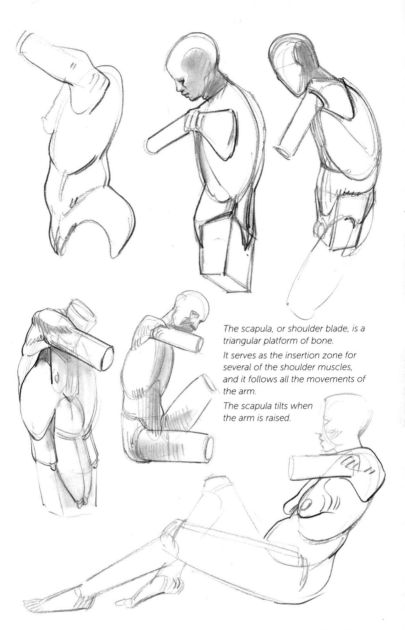

The scapula, or shoulder blade, is a triangular platform of bone.

It serves as the insertion zone for several of the shoulder muscles, and it follows all the movements of the arm.

The scapula tilts when the arm is raised.

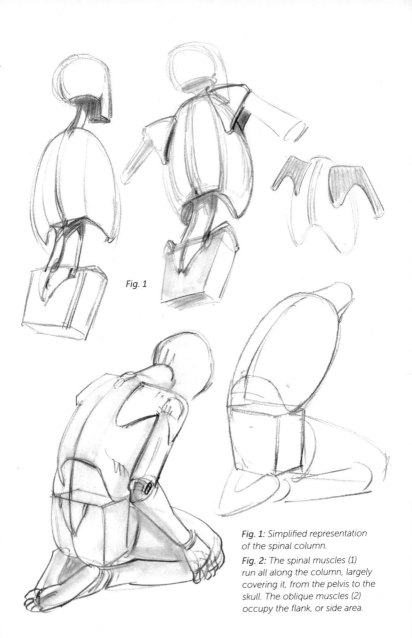

Fig. 1: Simplified representation of the spinal column.

Fig. 2: The spinal muscles (1) run all along the column, largely covering it, from the pelvis to the skull. The oblique muscles (2) occupy the flank, or side area.

Fig. 1

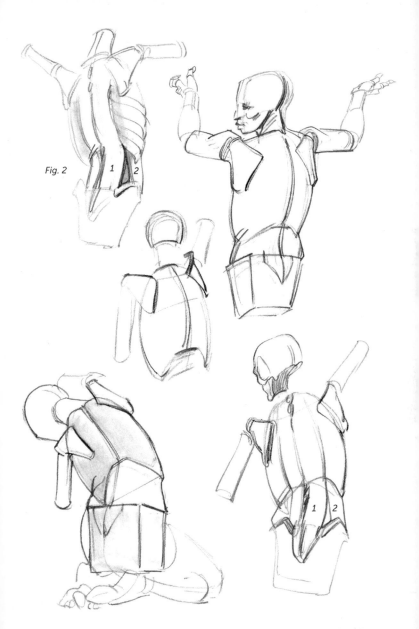

Fig. 2

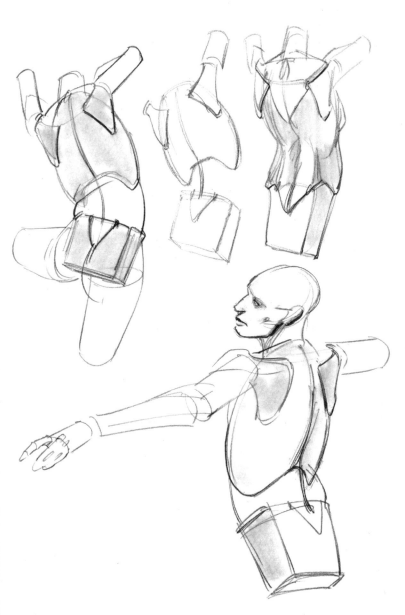

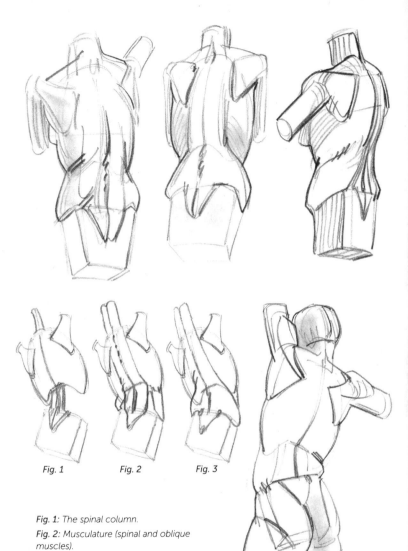

Fig. 1: The spinal column.

Fig. 1 *Fig. 2* *Fig. 3*

Fig. 1: The spinal column.
Fig. 2: Musculature (spinal and oblique muscles).
Fig. 3: Fat in the lumbar region.

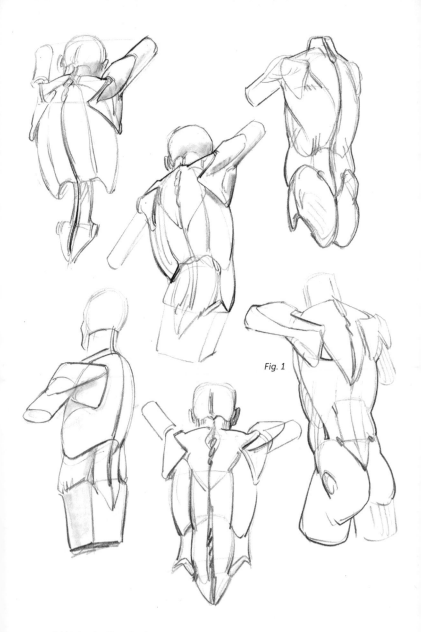

Fig. 1

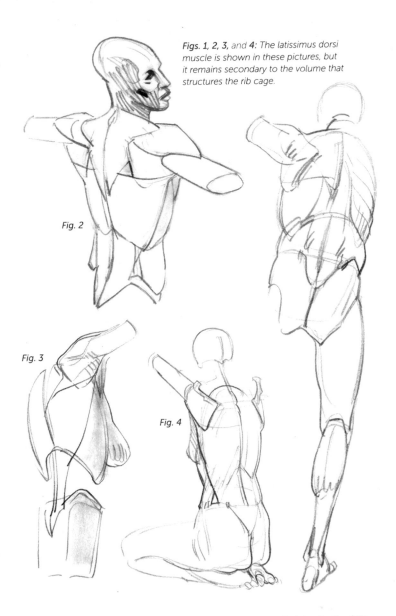

Figs. 1, 2, 3, and *4:* The latissimus dorsi muscle is shown in these pictures, but it remains secondary to the volume that structures the rib cage.

Fig. 2

Fig. 3

Fig. 4

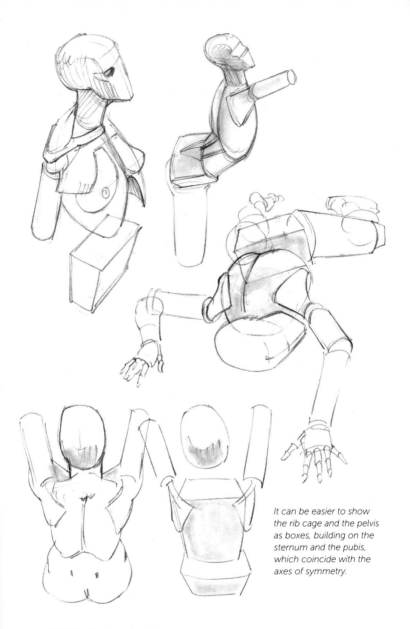

It can be easier to show
the rib cage and the pelvis
as boxes, building on the
sternum and the pubis,
which coincide with the
axes of symmetry.

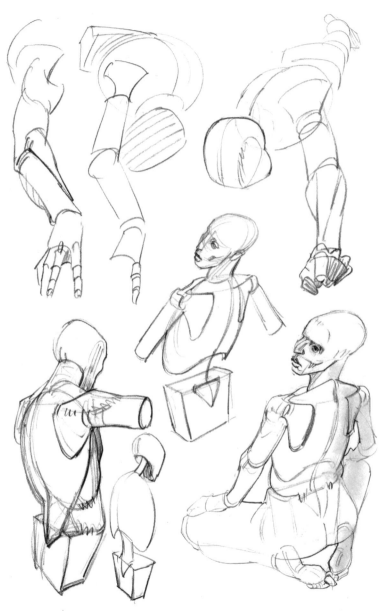

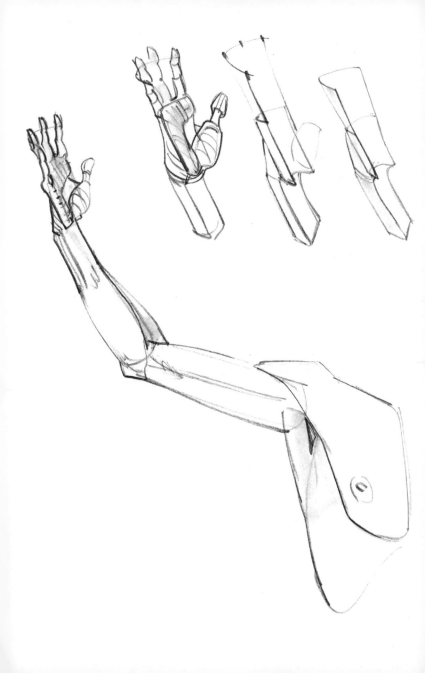

upper limb

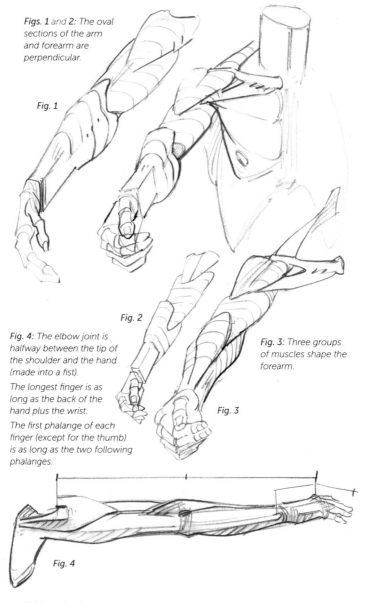

Figs. 1 and 2: The oval sections of the arm and forearm are perpendicular.

Fig. 1

Fig. 2

Fig. 4: The elbow joint is halfway between the tip of the shoulder and the hand (made into a fist).

The longest finger is as long as the back of the hand plus the wrist.

The first phalange of each finger (except for the thumb) is as long as the two following phalanges.

Fig. 3: Three groups of muscles shape the forearm.

Fig. 3

Fig. 4

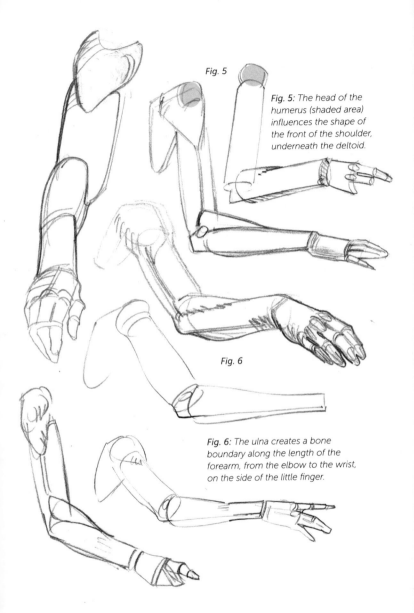

Fig. 5

Fig. 5: The head of the humerus (shaded area) influences the shape of the front of the shoulder, underneath the deltoid.

Fig. 6

Fig. 6: The ulna creates a bone boundary along the length of the forearm, from the elbow to the wrist, on the side of the little finger.

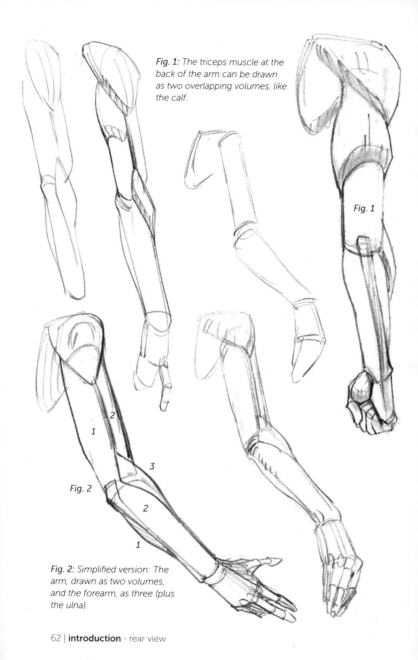

Fig. 1: The triceps muscle at the back of the arm can be drawn as two overlapping volumes, like the calf.

Fig. 1

1

2

3

2

1

Fig. 2

Fig. 2: Simplified version: The arm, drawn as two volumes, and the forearm, as three (plus the ulna).

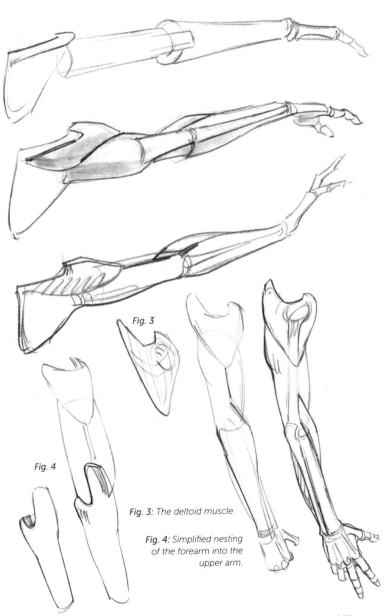

Fig. 3

Fig. 4

Fig. 3: The deltoid muscle.

Fig. 4: Simplified nesting of the forearm into the upper arm.

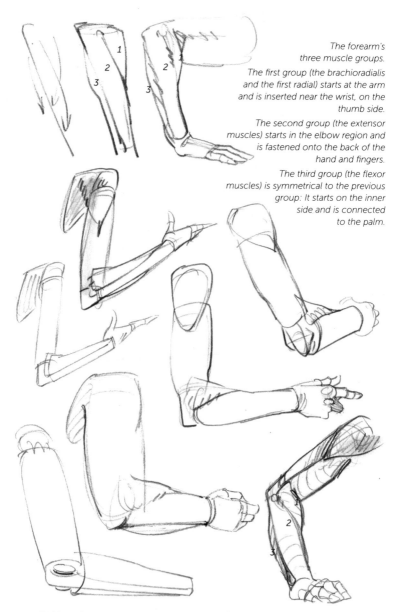

The forearm's three muscle groups.

The first group (the brachioradialis and the first radial) starts at the arm and is inserted near the wrist, on the thumb side.

The second group (the extensor muscles) starts in the elbow region and is fastened onto the back of the hand and fingers.

The third group (the flexor muscles) is symmetrical to the previous group: It starts on the inner side and is connected to the palm.

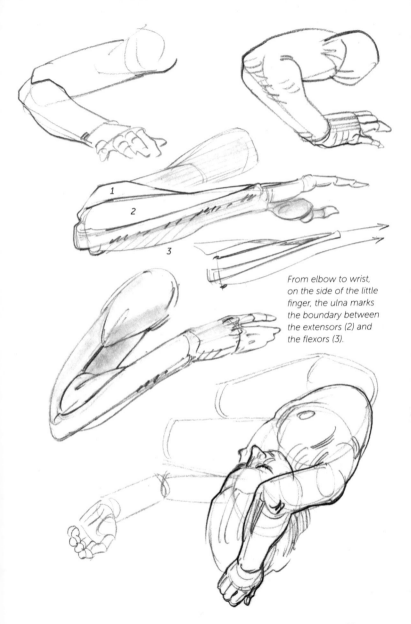

From elbow to wrist, on the side of the little finger, the ulna marks the boundary between the extensors (2) and the flexors (3).

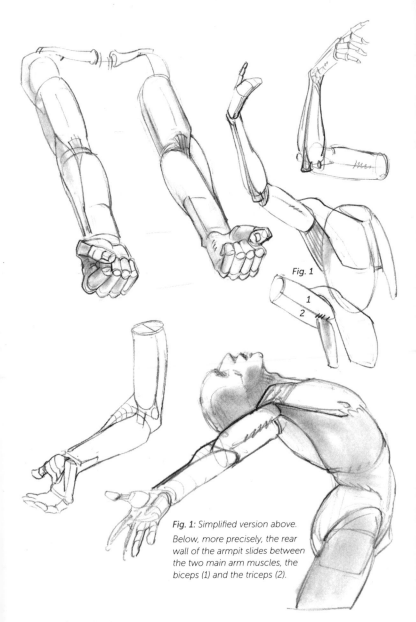

Fig. 1

1
2

Fig. 1: *Simplified version above.*

Below, more precisely, the rear wall of the armpit slides between the two main arm muscles, the biceps (1) and the triceps (2).

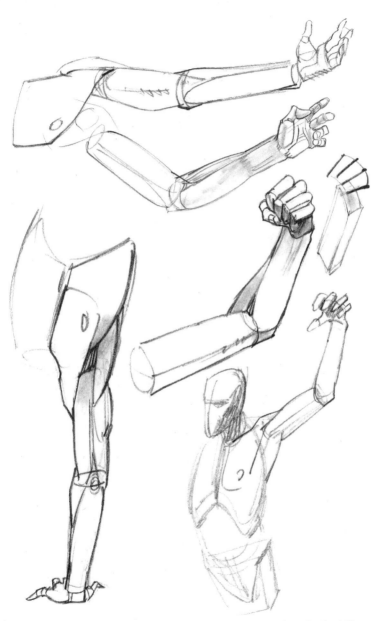

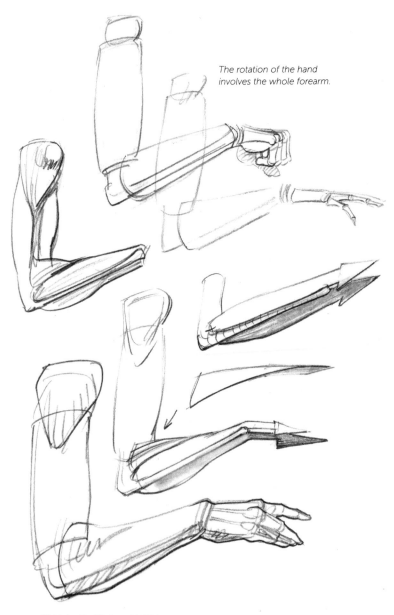

The rotation of the hand involves the whole forearm.

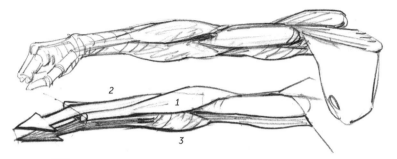

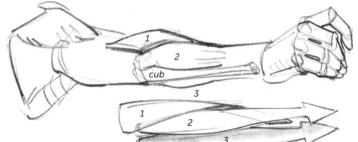

2

1

3

1

2

cub

3

1

2

3

Remember that the ulna stays on the little finger side of the forearm all the way to the wrist, whereas on the thumb side, it is the group of the brachioradialis and first radial muscles (1) that marks the separation between the extensors (2) and the flexors (3).

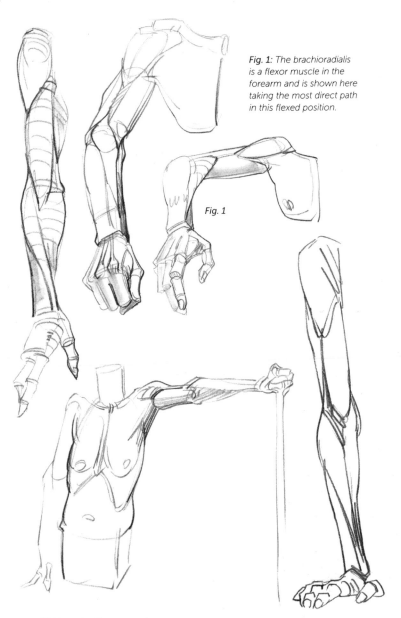

Fig. 1: The brachioradialis is a flexor muscle in the forearm and is shown here taking the most direct path in this flexed position.

Fig. 1

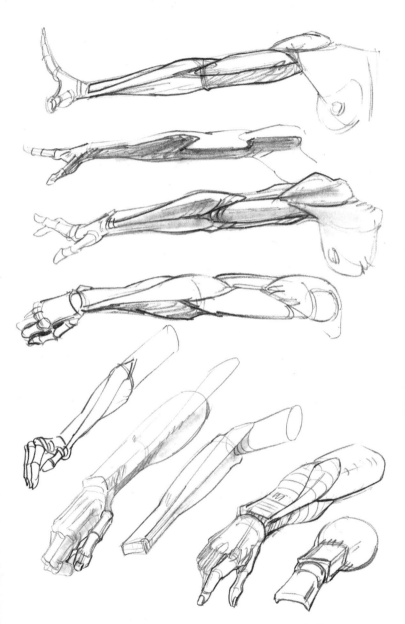

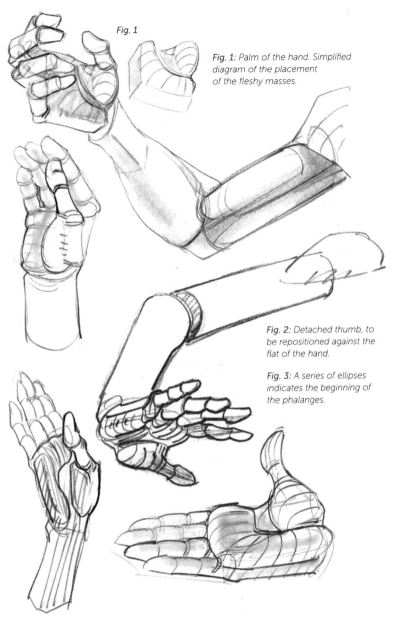

Fig. 1

Fig. 1: Palm of the hand. Simplified diagram of the placement of the fleshy masses.

Fig. 2: Detached thumb, to be repositioned against the flat of the hand.

Fig. 3: A series of ellipses indicates the beginning of the phalanges.

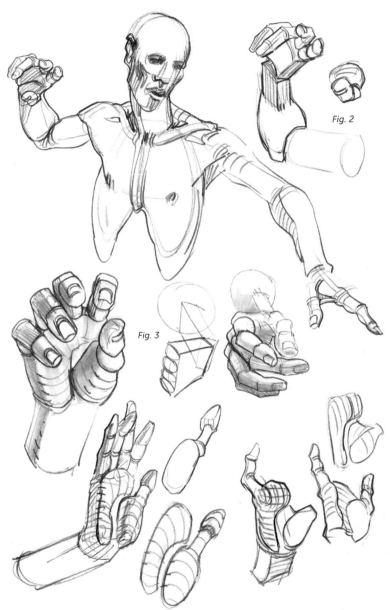

Fig. 2

Fig. 3

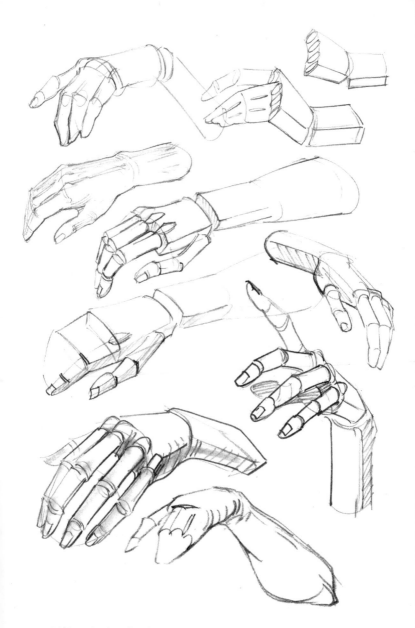

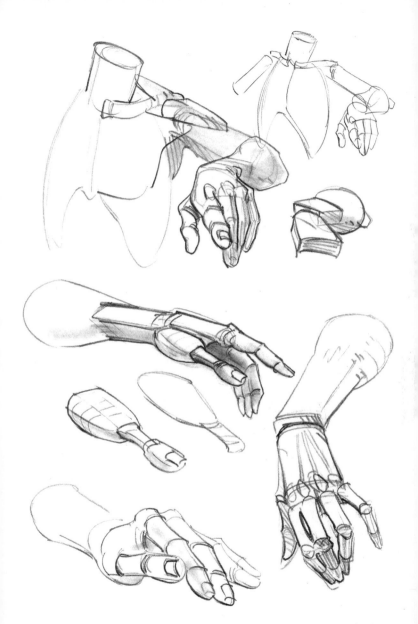

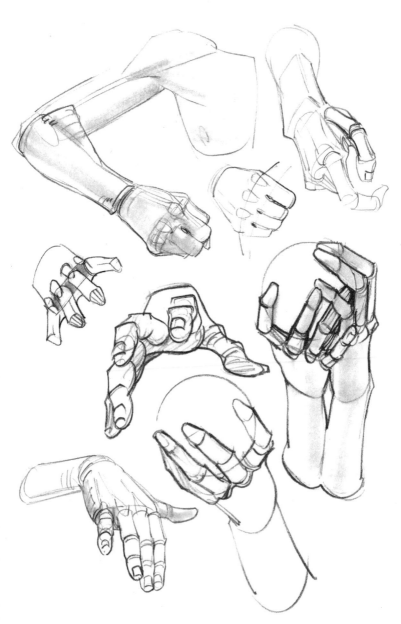

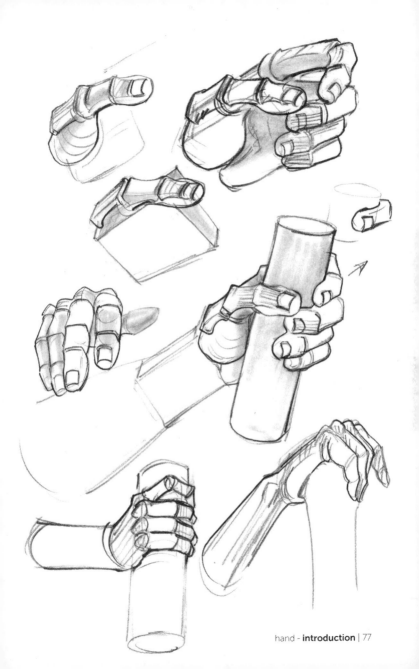

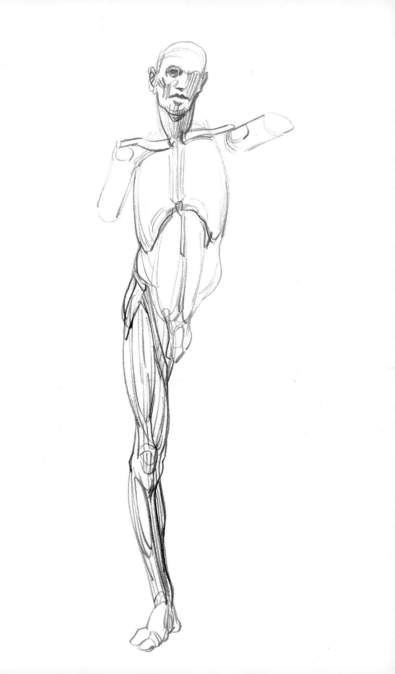

lower limb

Fig. 1: An oblique line separates the thigh into two volumes (quadriceps/adductors).

Fig. 2: From the hip joint to the floor, the halfway point can be placed at the bottom of the patella.

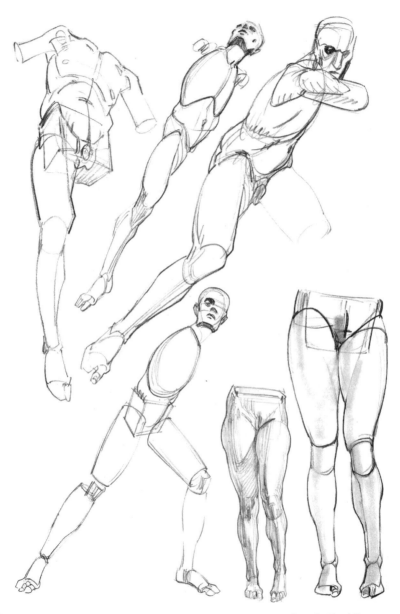

Fig. 1

Fig. 1: In a foreshortened view from the front, in a seated position, the nesting of the two volumes makes it possible to express depth.

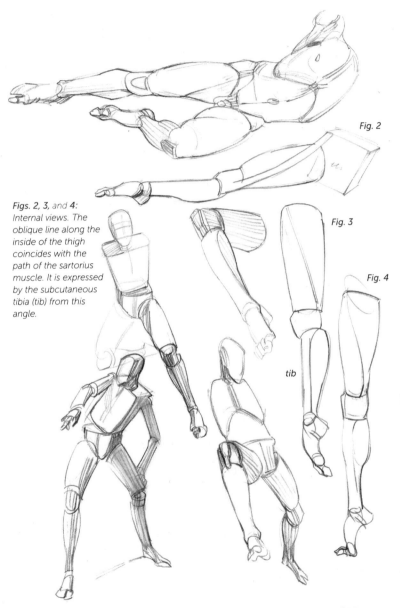

Figs. 2, 3, and **4:** Internal views. The oblique line along the inside of the thigh coincides with the path of the sartorius muscle. It is expressed by the subcutaneous tibia (tib) from this angle.

Fig. 2

Fig. 3

Fig. 4

tib

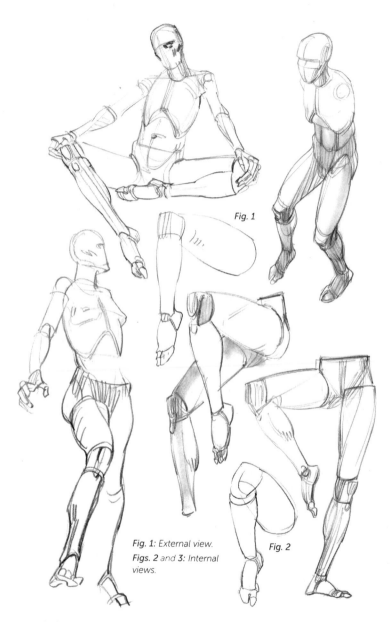

Fig. 1

Fig. 1: External view.
Figs. 2 and 3: Internal views.

Fig. 2

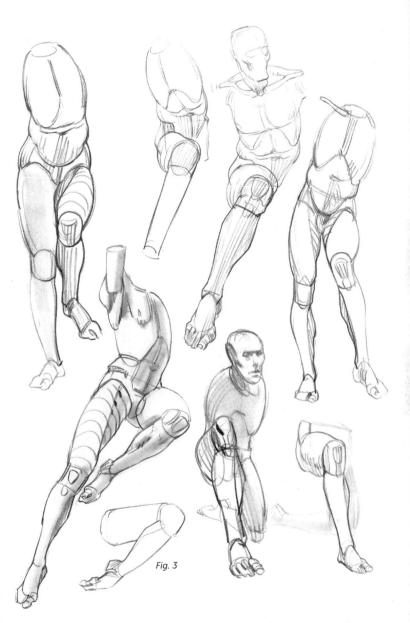

Fig. 3

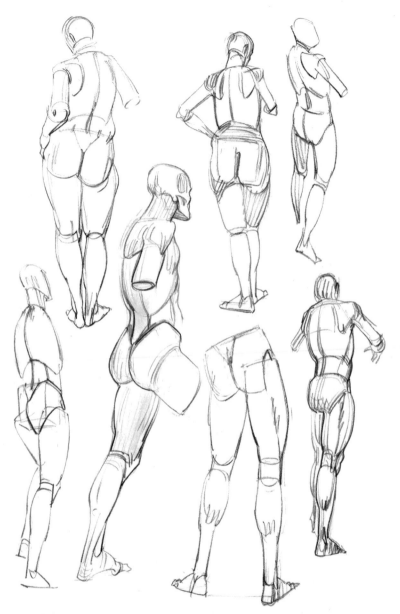

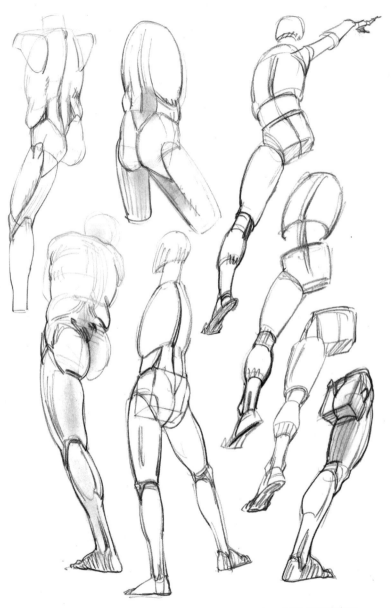

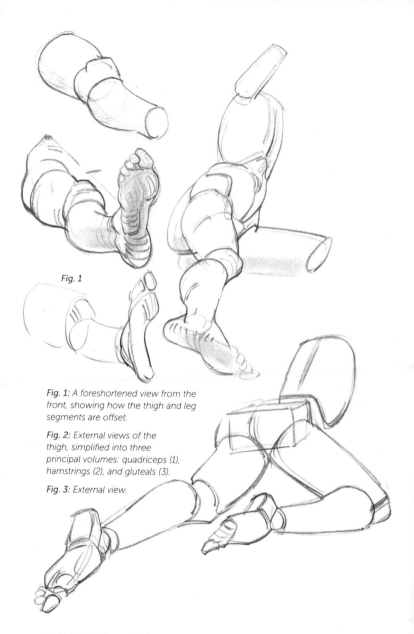

Fig. 1: A foreshortened view from the front, showing how the thigh and leg segments are offset.

Fig. 2: External views of the thigh, simplified into three principal volumes: quadriceps (1), hamstrings (2), and gluteals (3).

Fig. 3: External view.

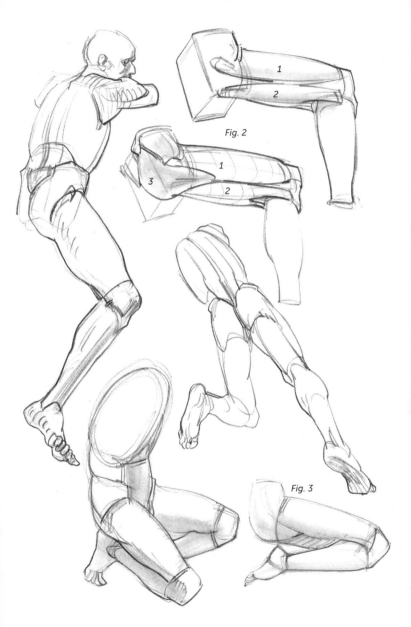

Fig. 2

Fig. 3

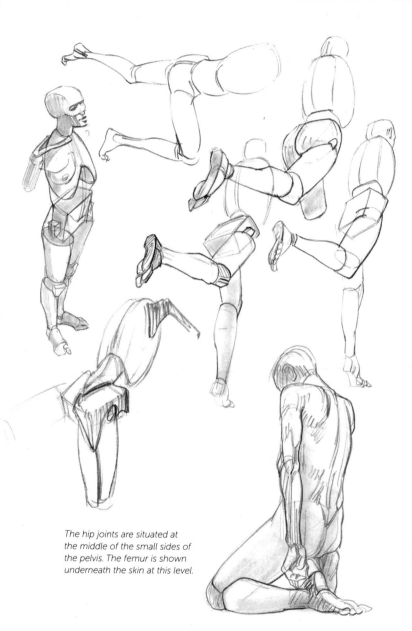

The hip joints are situated at the middle of the small sides of the pelvis. The femur is shown underneath the skin at this level.

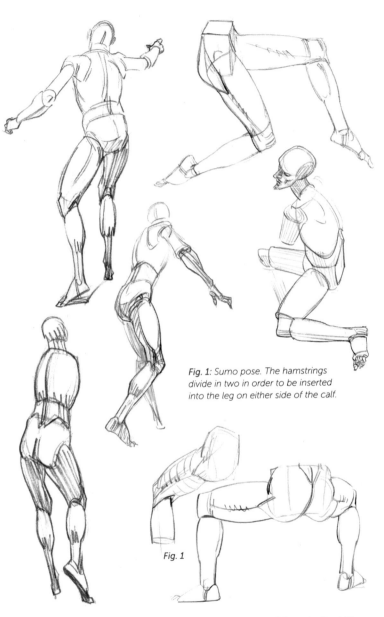

Fig. 1: Sumo pose. The hamstrings divide in two in order to be inserted into the leg on either side of the calf.

Fig. 1

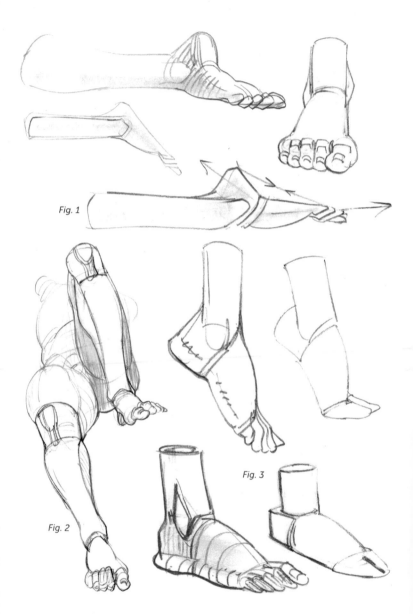

Fig. 1

Fig. 2

Fig. 3

Fig. 4

Fig. 5

Fig. 1: The foot folds back onto itself at the level of the "kick."

Fig. 2: The sinuous line that runs from the inside of the knee to the inside ankle (or internal malleolus) corresponds to the tibia, which is subcutaneous from top to bottom.

Fig. 3: Outer view.

Fig. 4: Simple diagram of the plantar arch.

Fig. 5: Inner views.

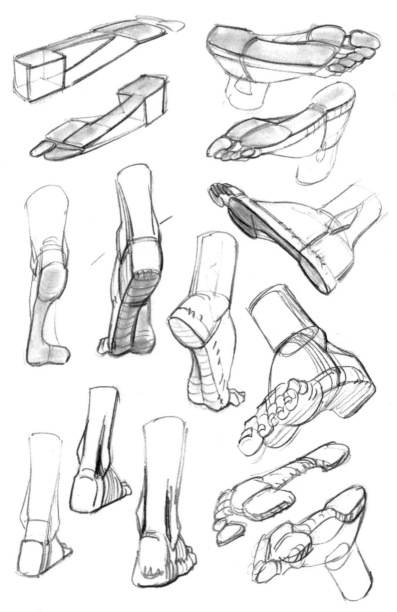

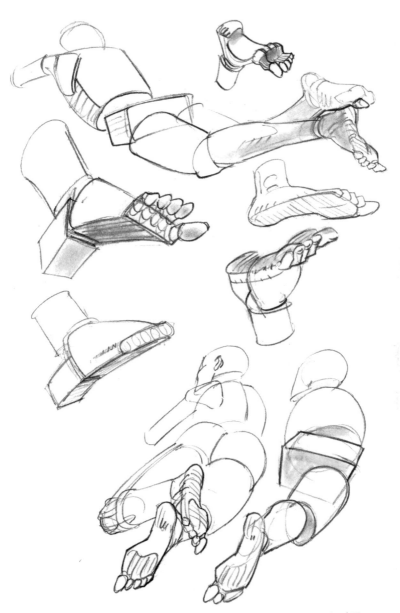

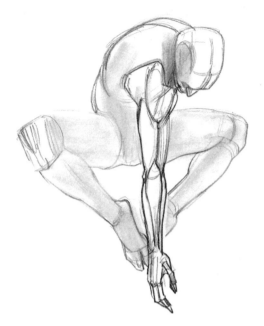

resources

In the making of this book, I owe a great deal to the work of the French comic book author Raymond Poivet.

The Human Machine,
George B. Bridgman,
Dover Publications, New York, 1972.

Constructive Anatomy,
George B. Bridgman,
Dover Publications, New York, 1973.

Figure Drawing: Design and Invention,
Michael Hampton,
Michael Hampton, 2009.
www.figuredrawing.info

100 Tuesday Tips,
Griz and Norm,
Griselda Sastrawinata-Lemay
and Normand Lemay, 2015.

Drawing Manual,
Glenn Vilppu,
Vilppu Studio-Spi edition, 1997.

Le Dessin de nu (For French speakers),
Thomas Wienc,
Dessain et Tolra, Paris, 2010.